WALL ART MADE

Vincent van Gogh

30 Ready to Frame Reproduction Prints

Barbara Ann Kirby

ISBN-9781709349386

INTRODUCTION

Wall Art Made Easy: Vincent van Gogh: 30 Ready to Frame Reproduction Prints features thirty prints of paintings by Vincent Willem van Gogh (1853-1890), the most famous Dutch post-impressionist painter of all time.

Within these pages, you will find thirty vibrant full color portrait and landscape oriented prints of some of his most famous paintings including The Starry Night, Sunflowers, Irises, Bedroom in Arles, Wheat Field with Cypresses as well as many more beautiful artworks.

If you're a fan of Vincent van Gogh you're sure to find some that you'll love enough to want to display on your walls in all their glory.

Each image is ideal for a 8" x 10" frame with a 1" mat and can be easily removed from the book by cutting along the line shown on the page.

Easily transform your home décor using *Wall Art Made Easy: Vincent van Gogh: 30 Ready to Frame Reproduction Prints*, the far cheaper alternative to buying expensive prints!

First Steps

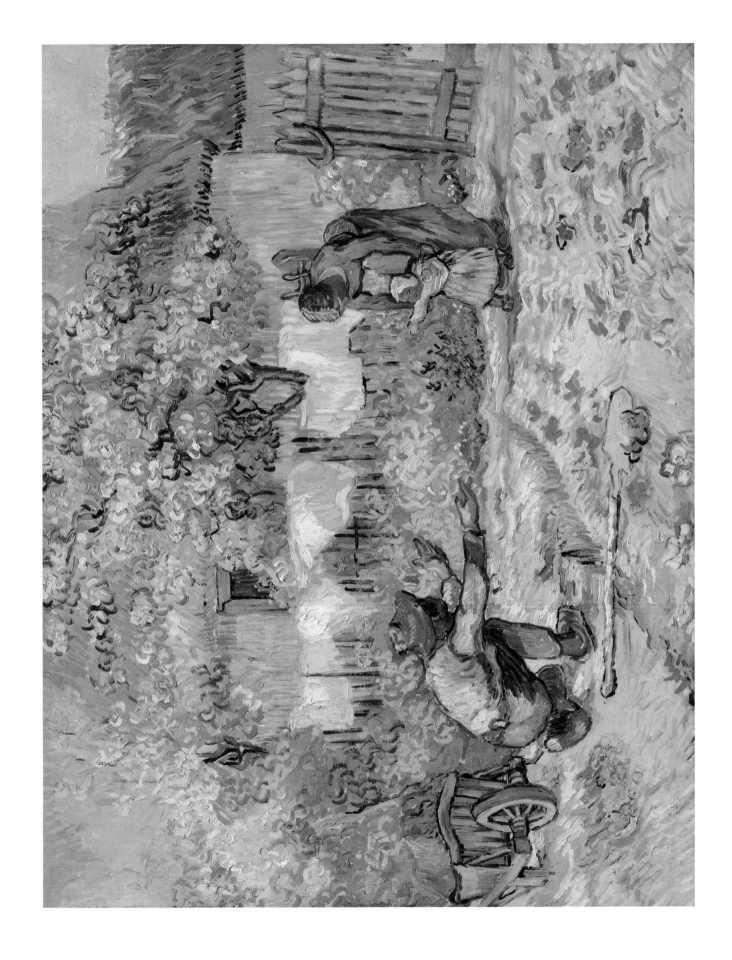

Cypresses

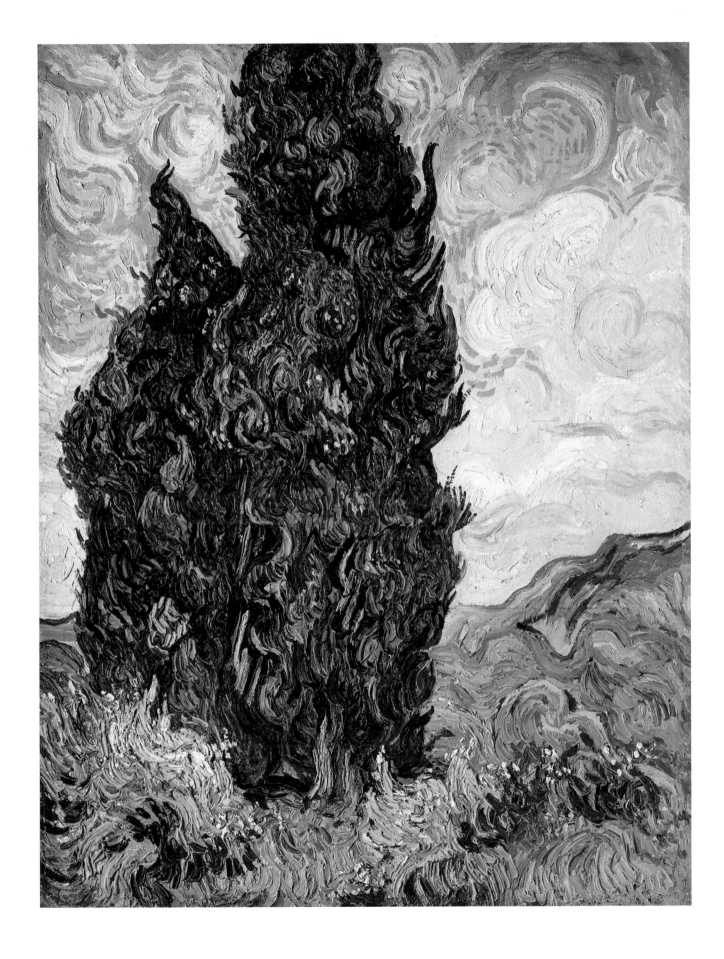

Irises

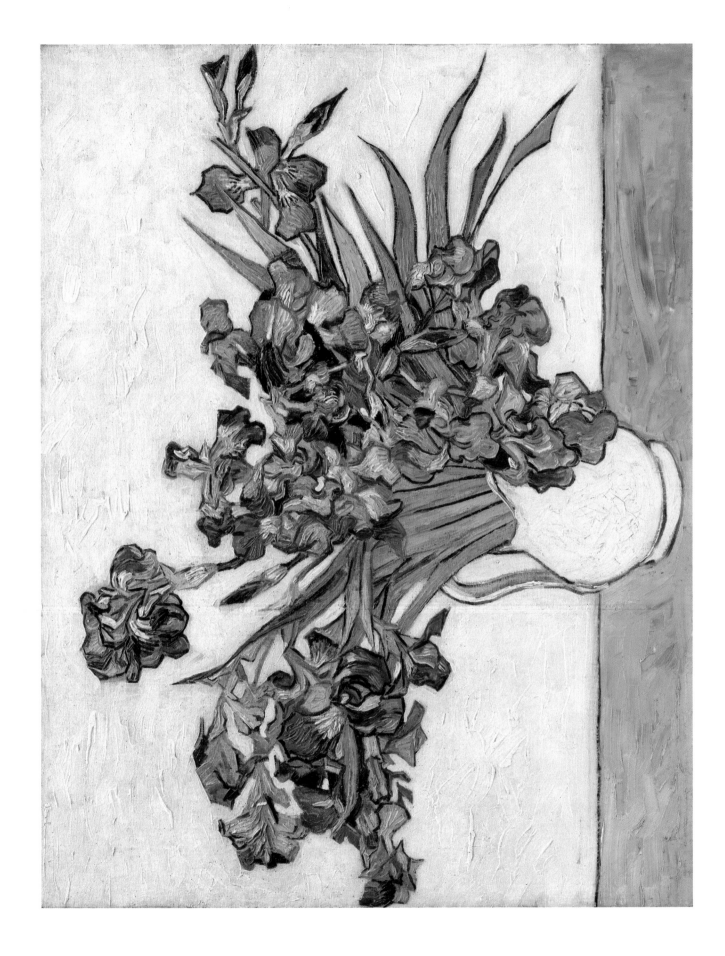

Sunflowers

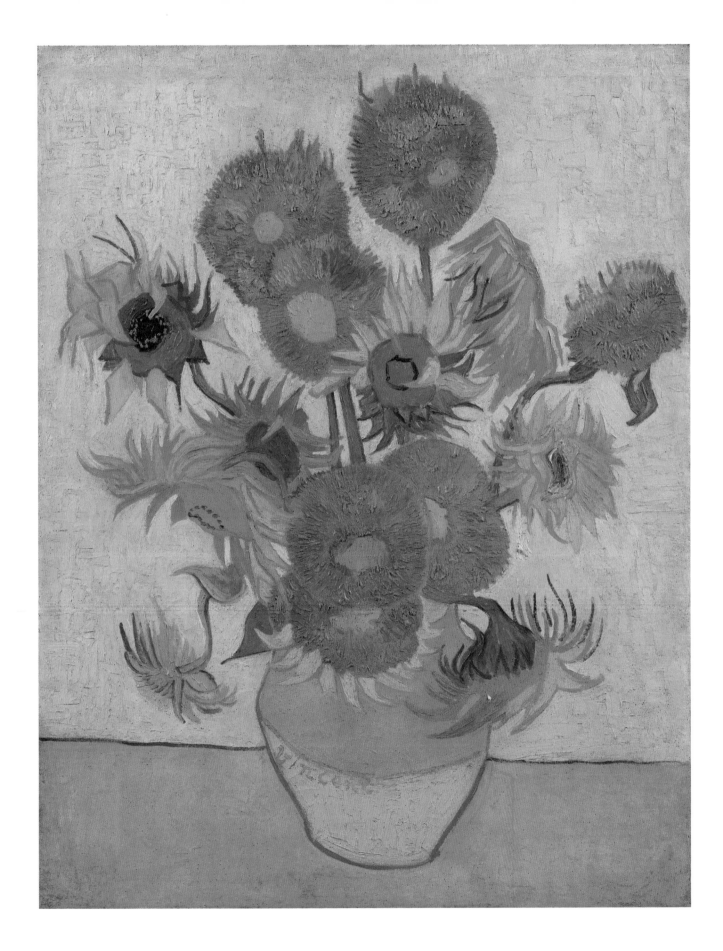

Irises

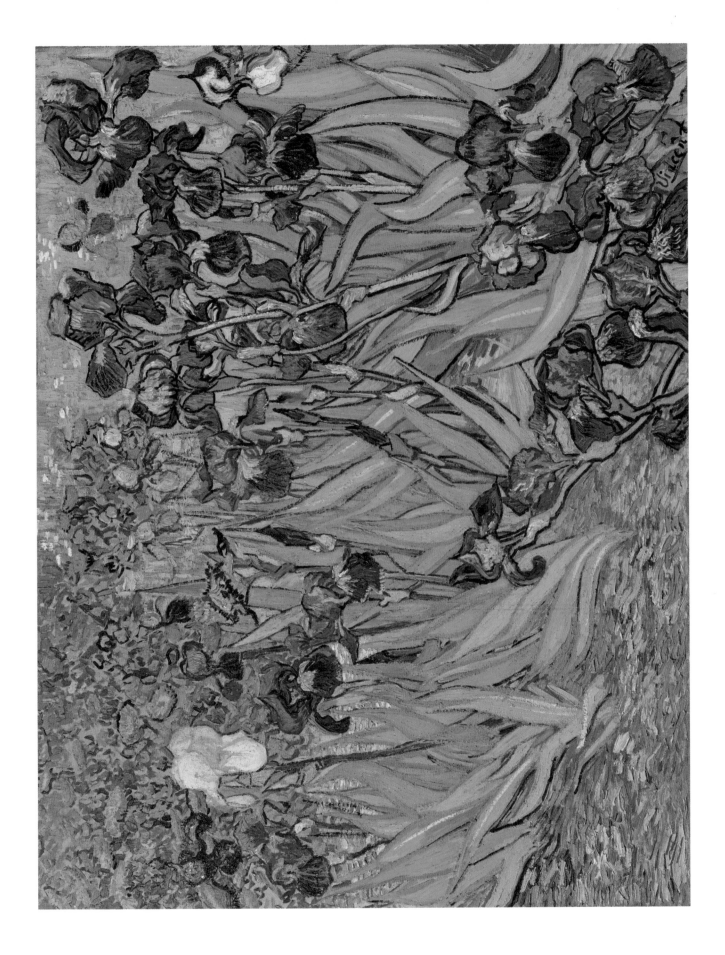

Wheat Field with Cypresses

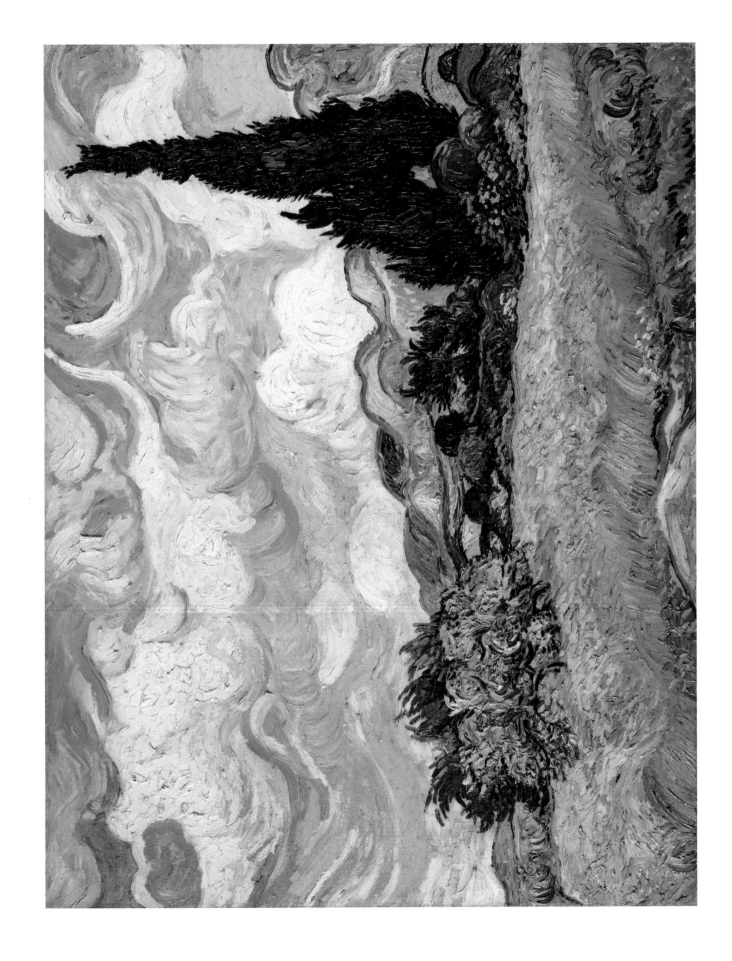

Olive Trees

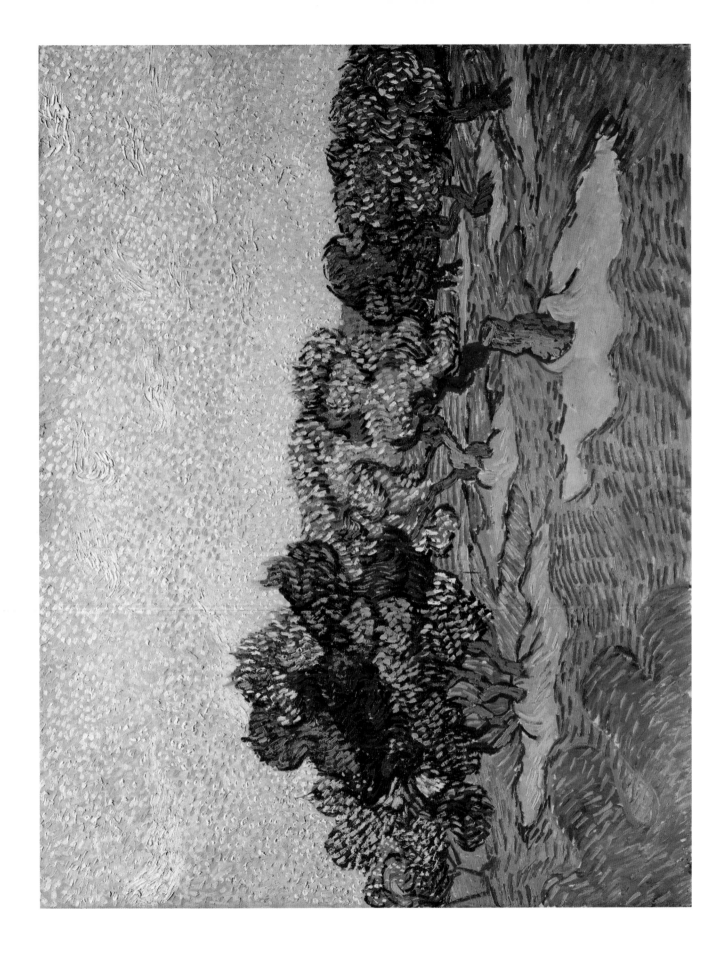

Shoes

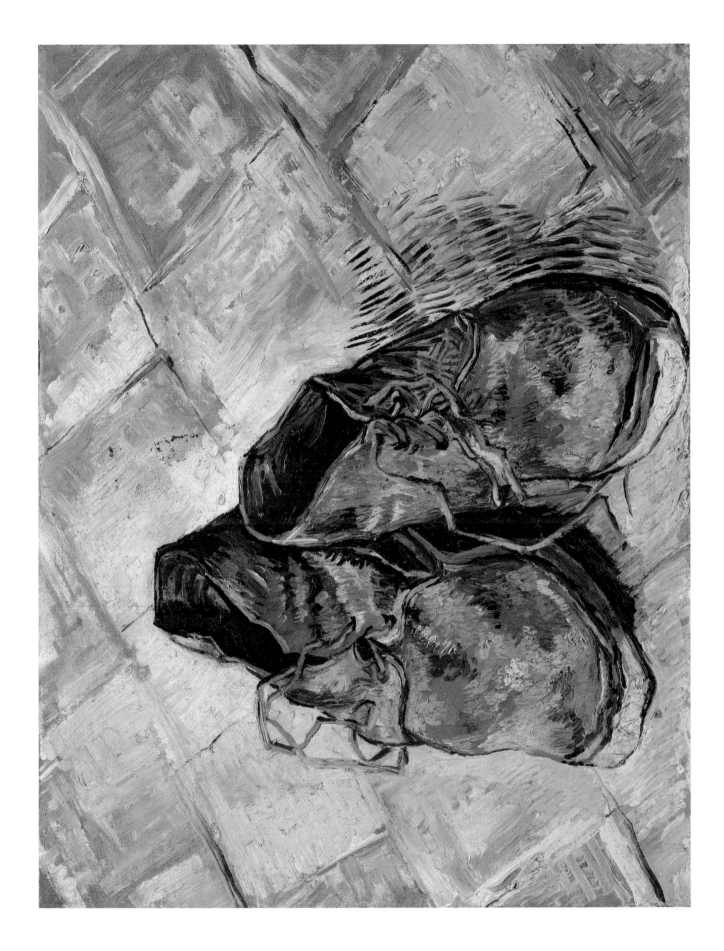

The Flowering Orchard

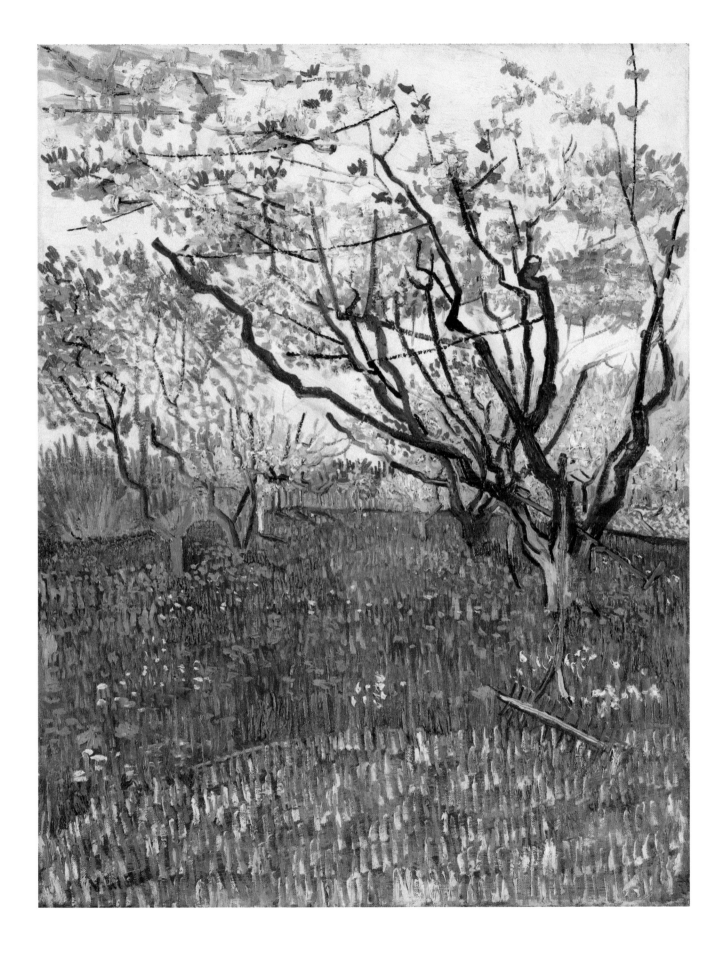

Bouquet of Flowers in a Vase

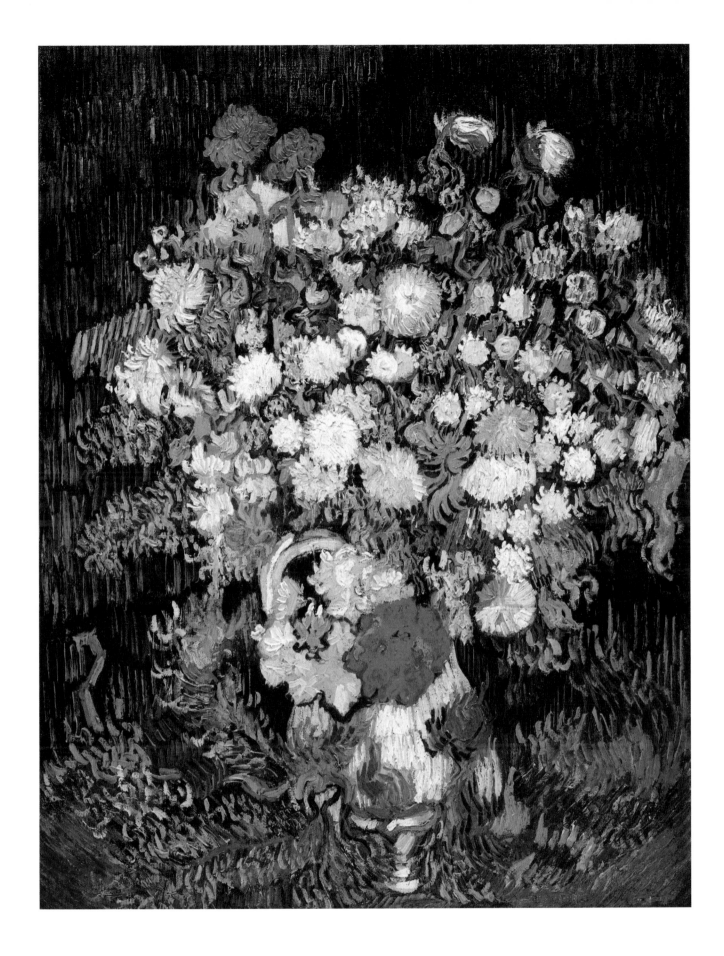

Fishing in Spring

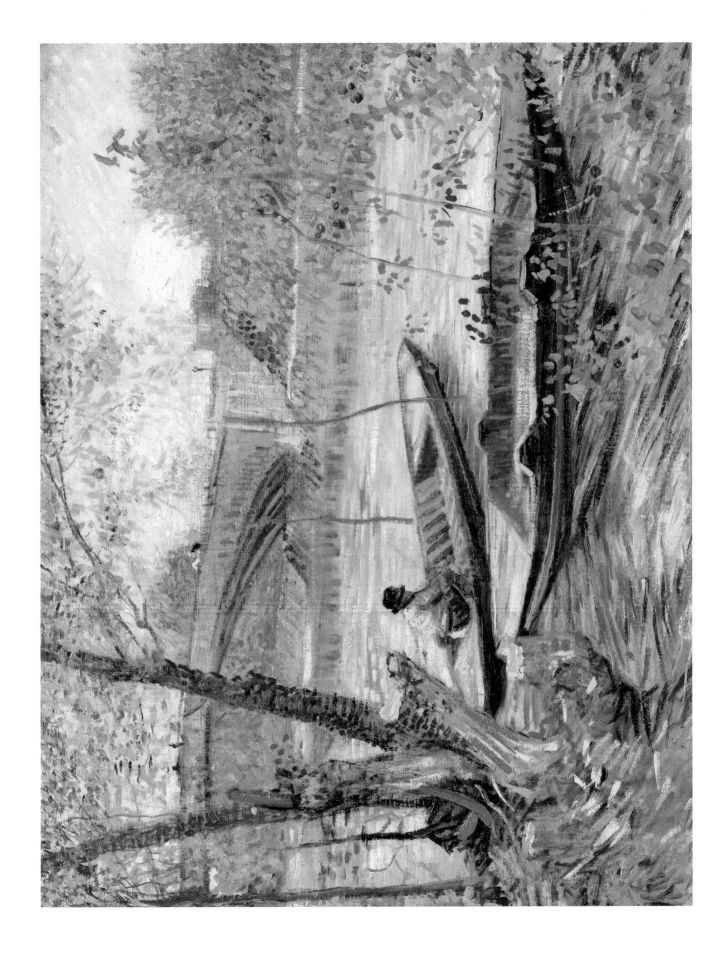

Grapes, Lemons, Pears and Apples

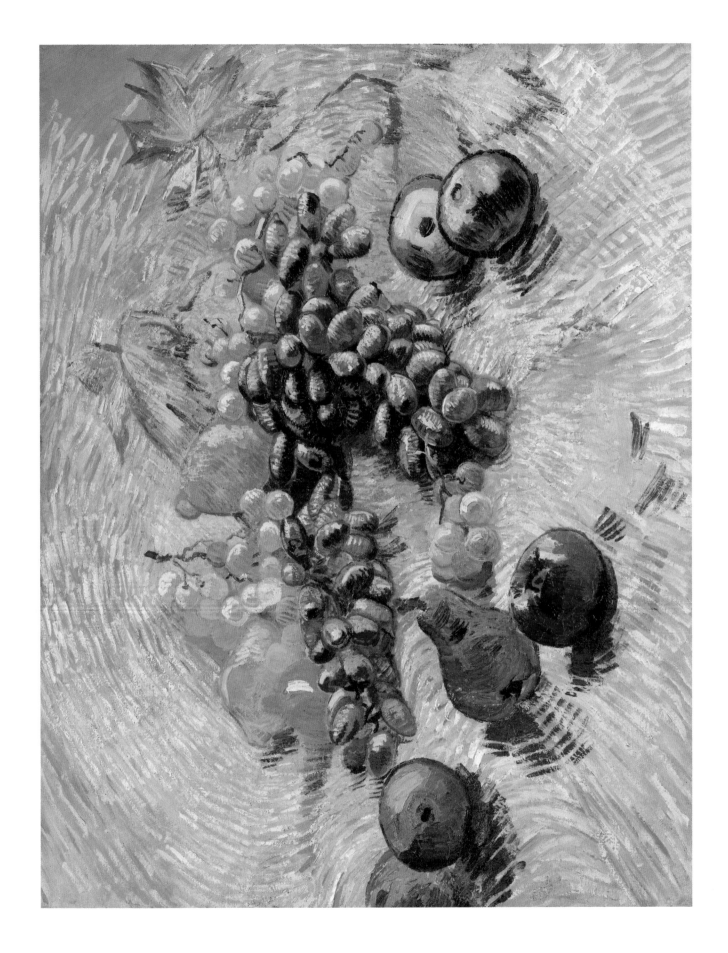

La Berceuse

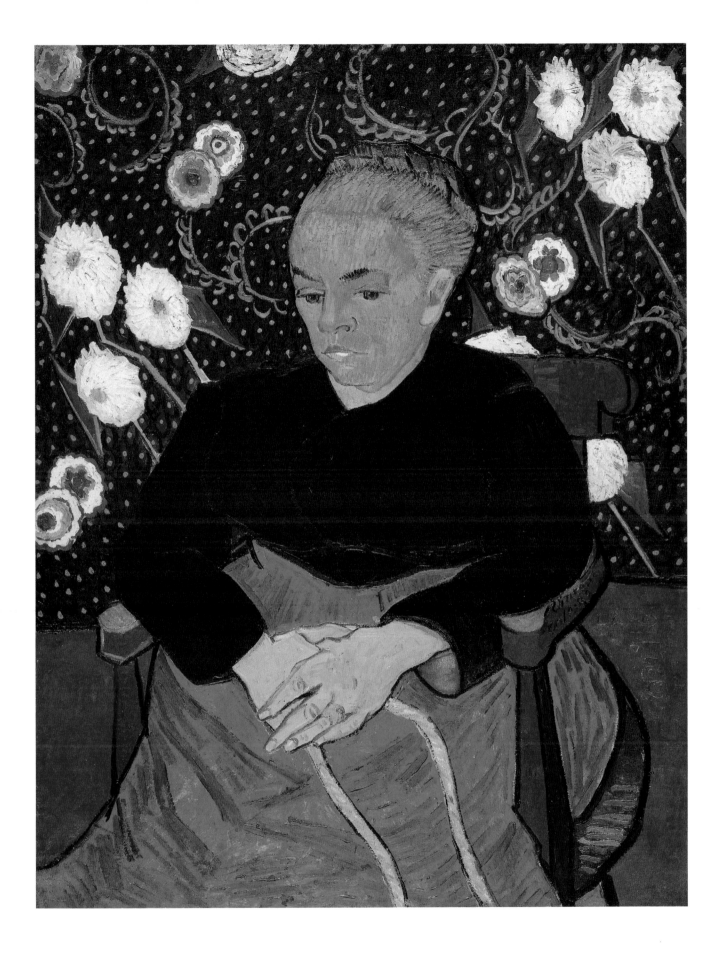

Houses and Figure

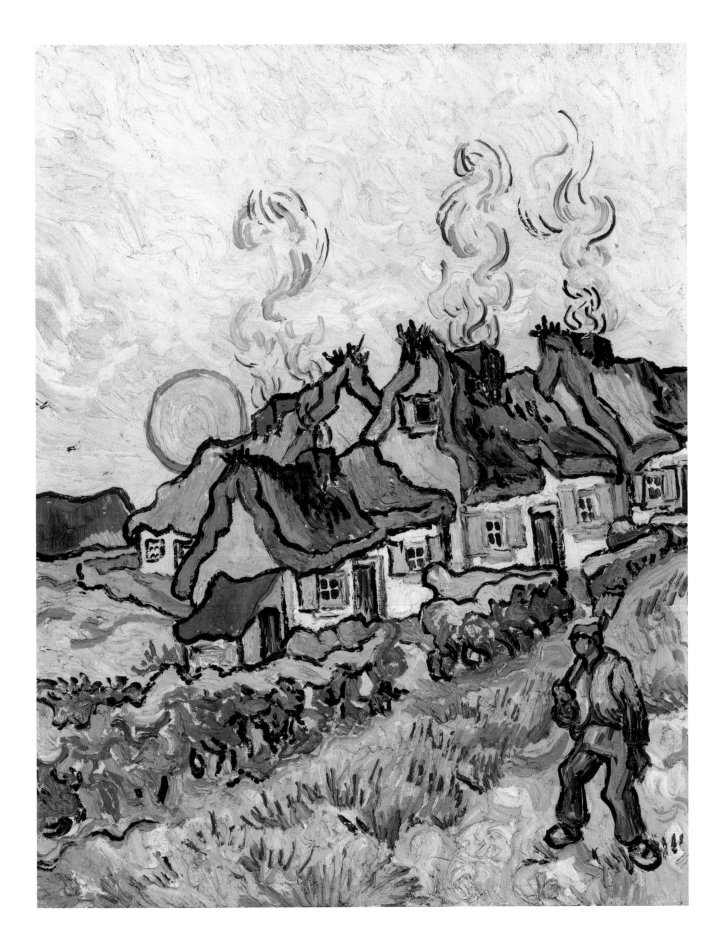

The Factory

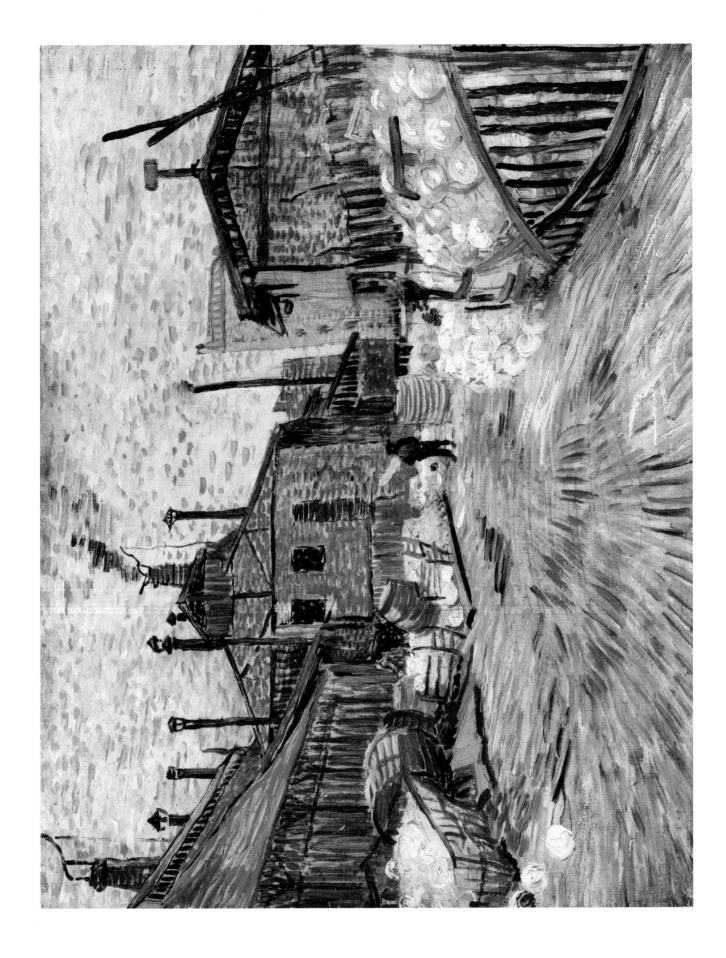

Le Café de Nuit

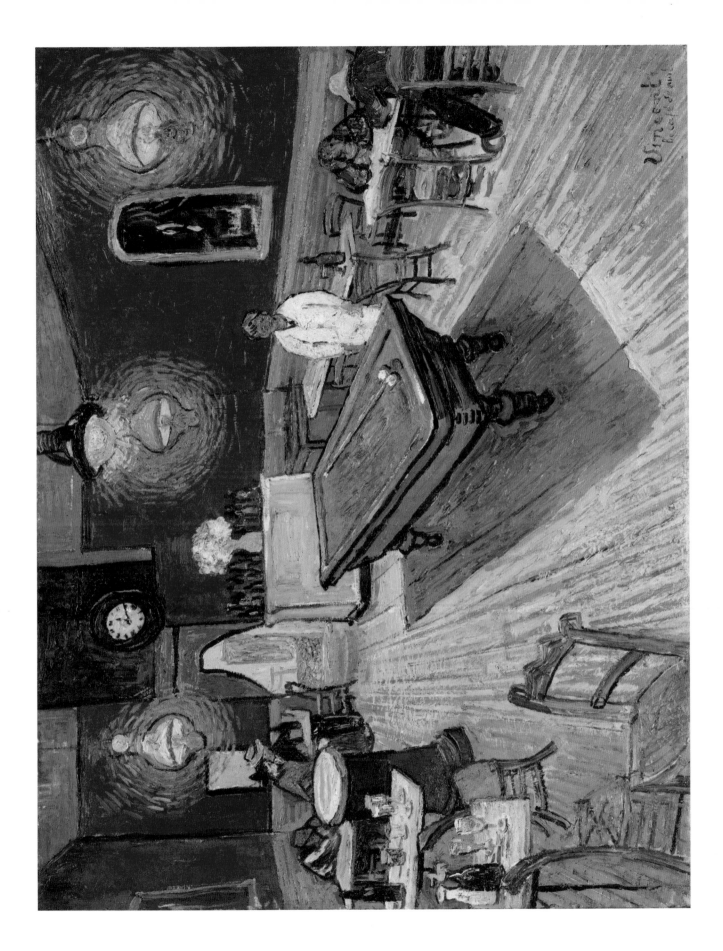

The Poplars at Saint-Rémy

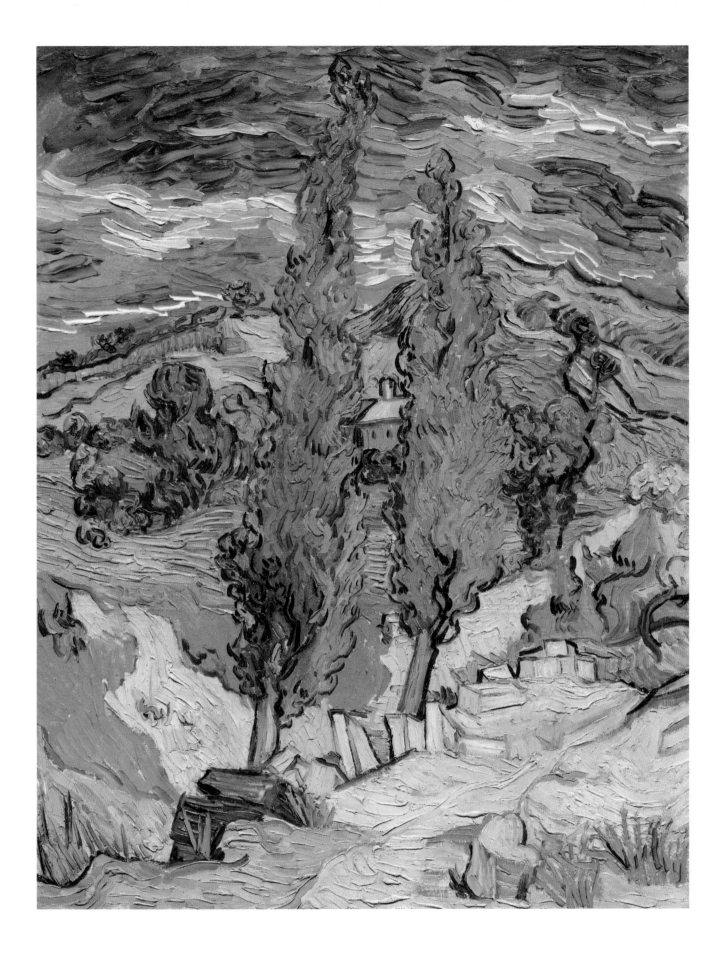

Green Wheat Fields, Auvers

Self portrait

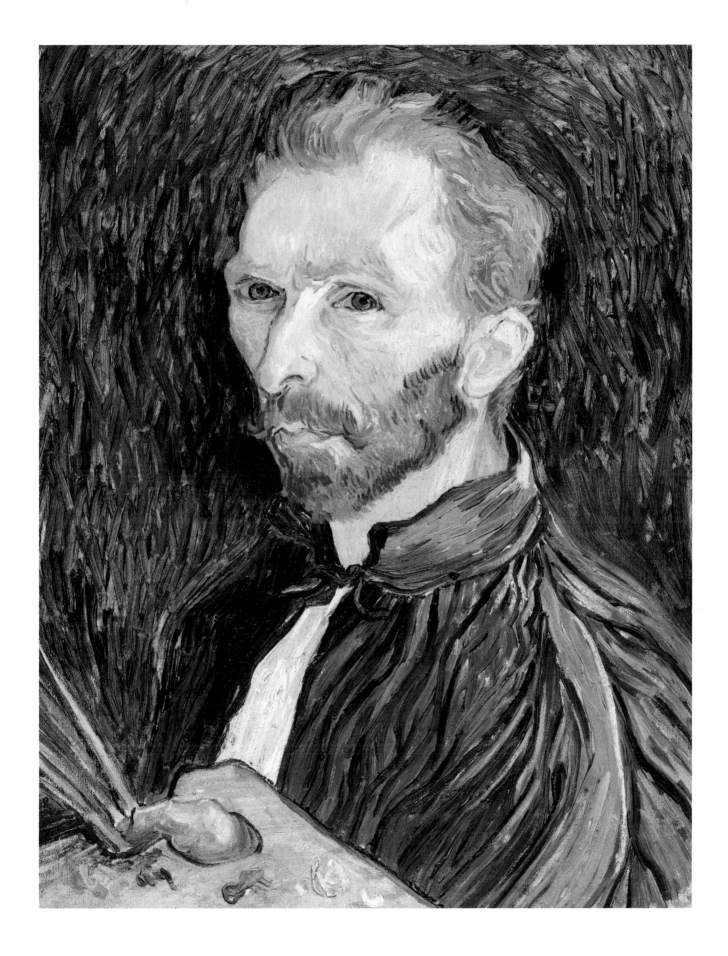

Farmhouse in Provence

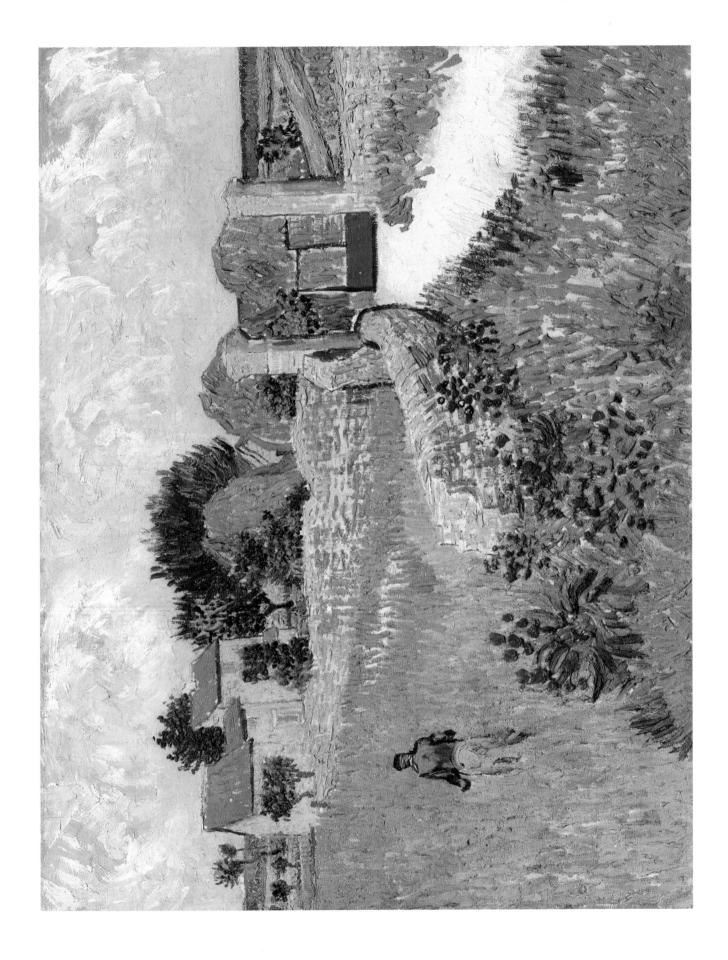

Still Life

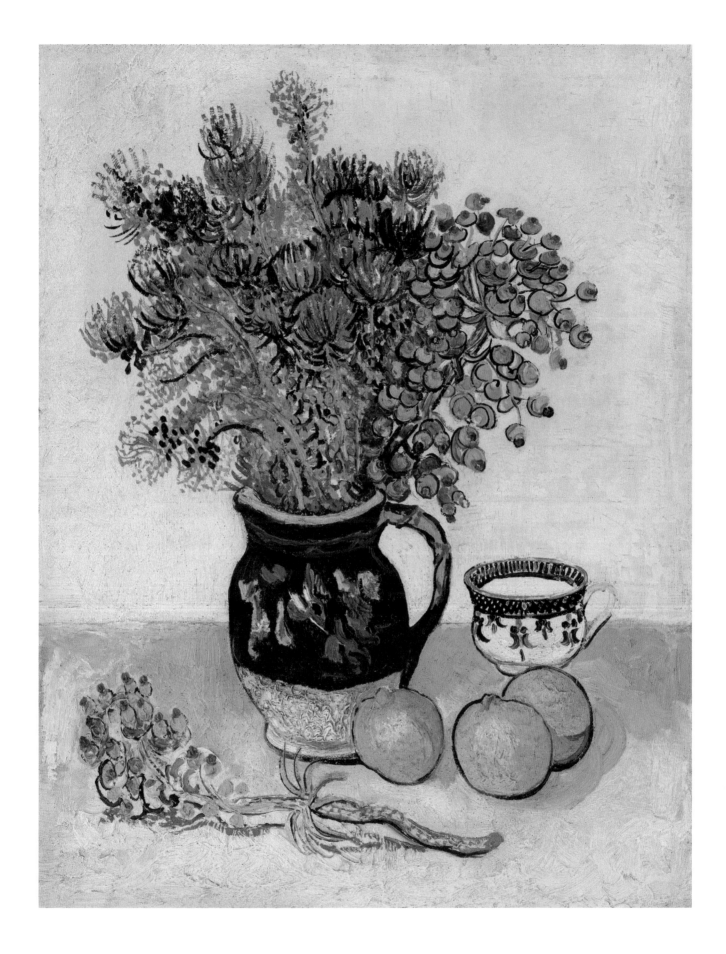

Square Saint-Pierre, Paris

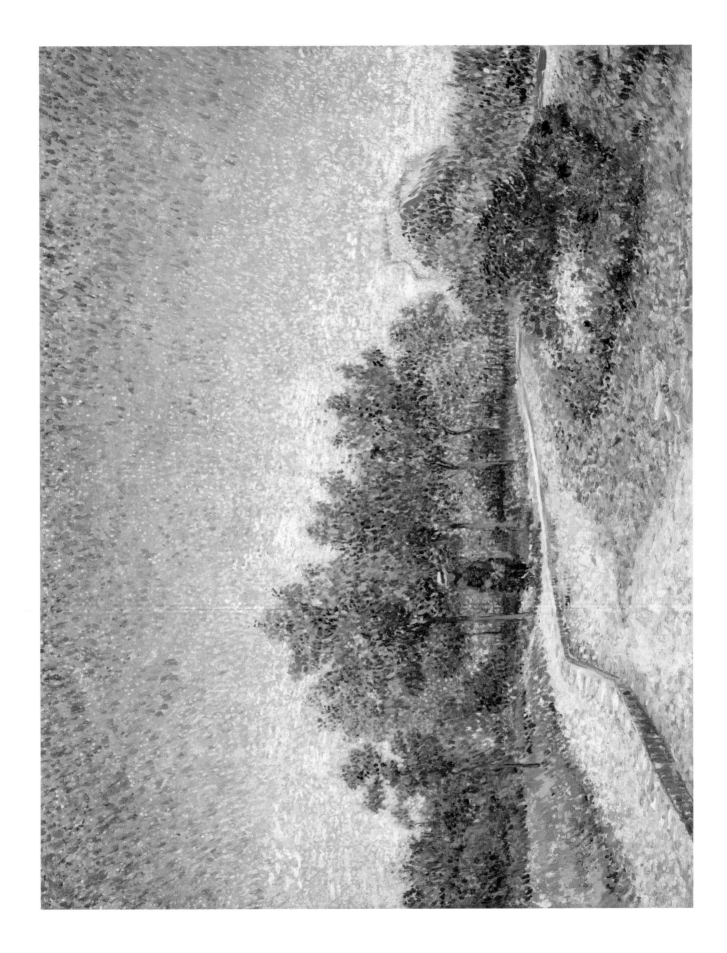

The Starry Night

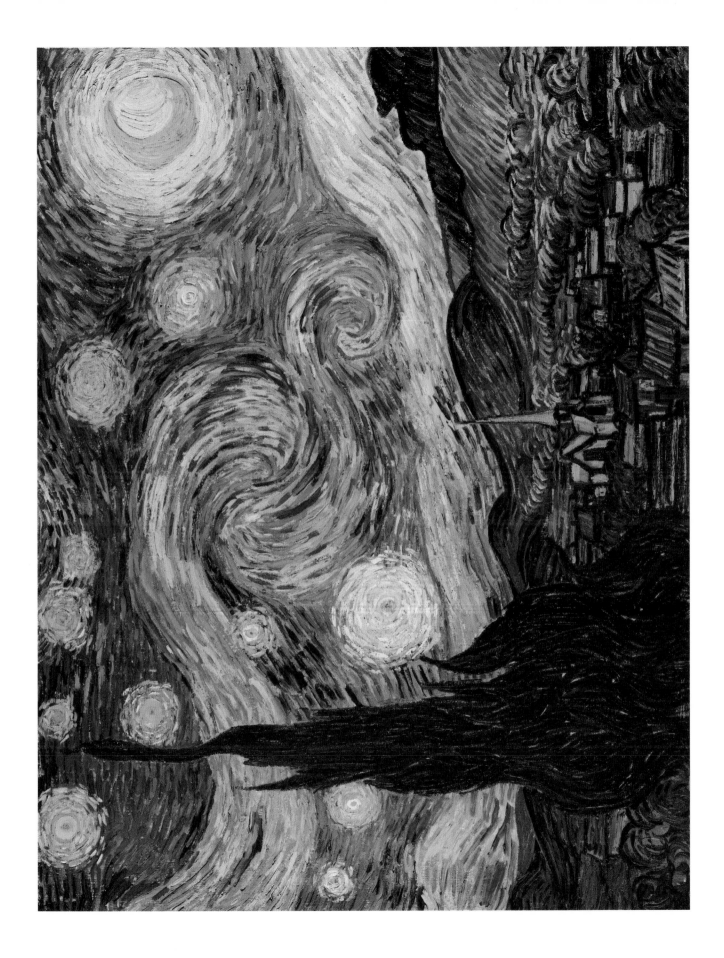

Terrace and Observation Deck at the Moulin de Blute-Fin, Montmartre

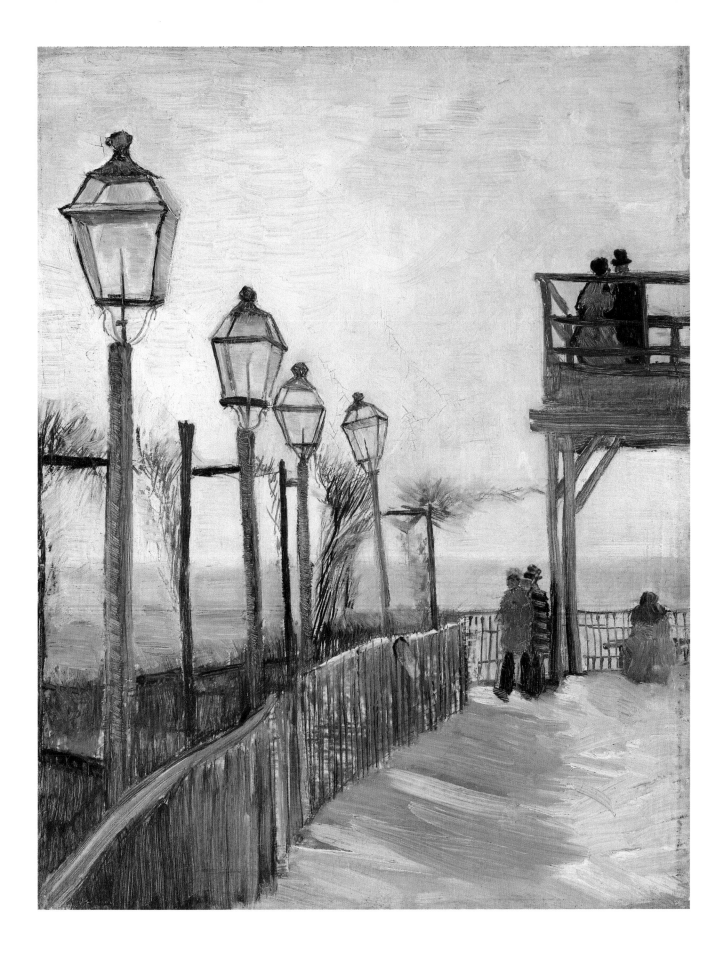

Bedroom in Arles

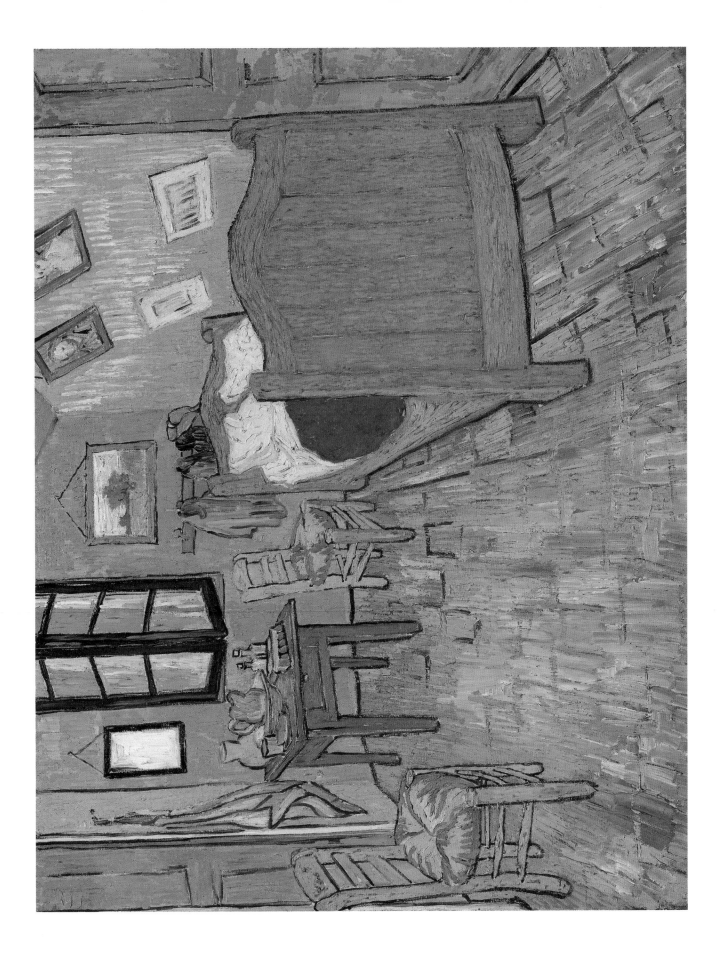

The Drinkers

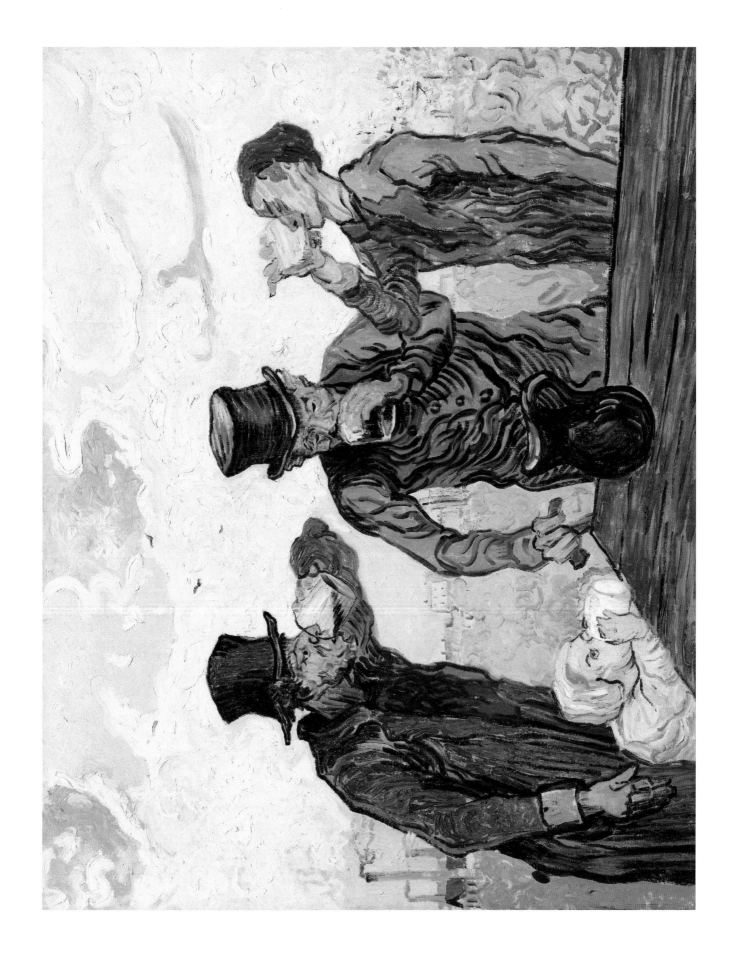

The Poet's Garden

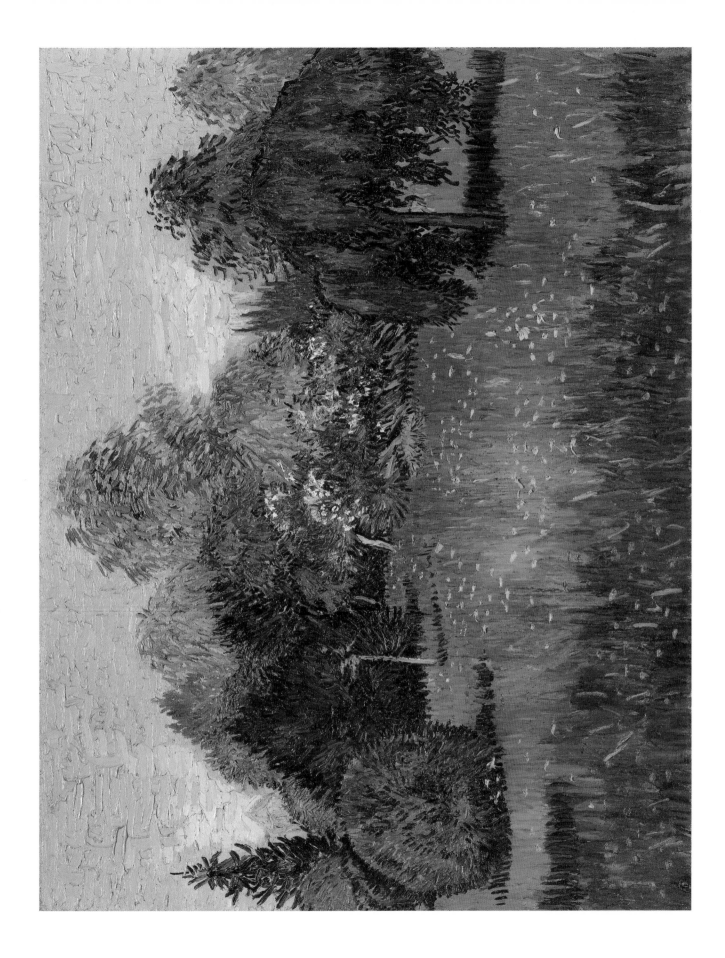

Roses

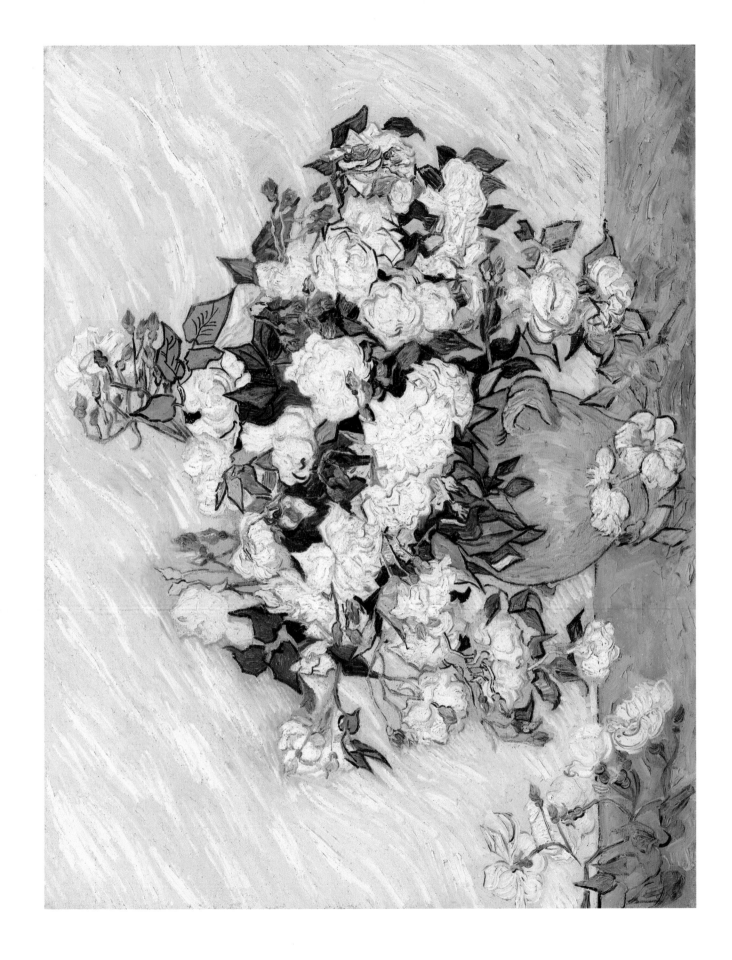

Self portrait

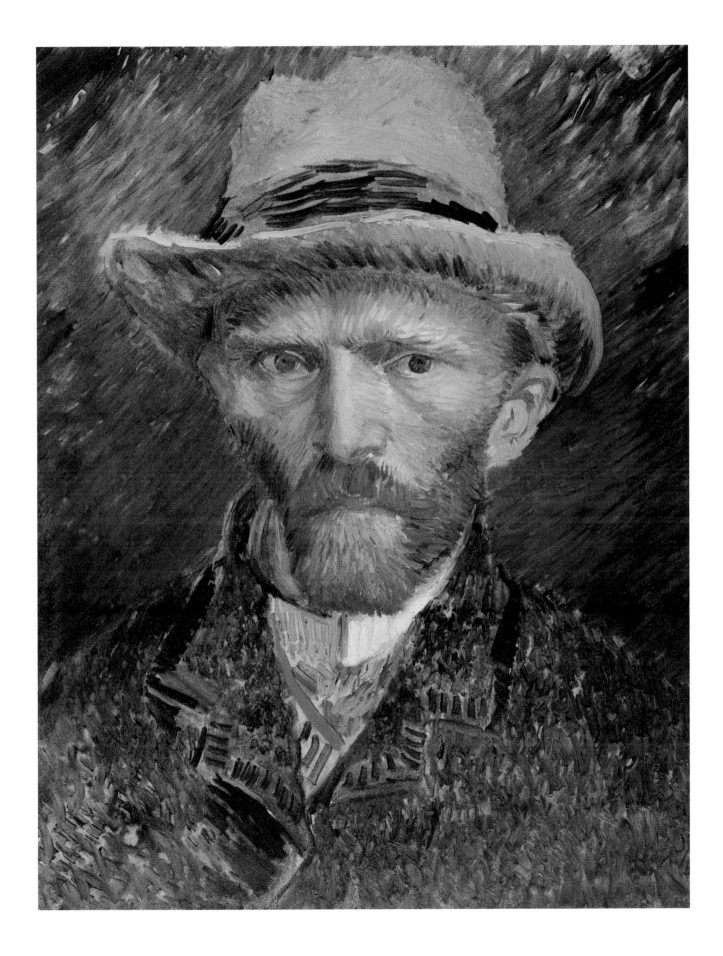

Orchard Bordered by Cypresses

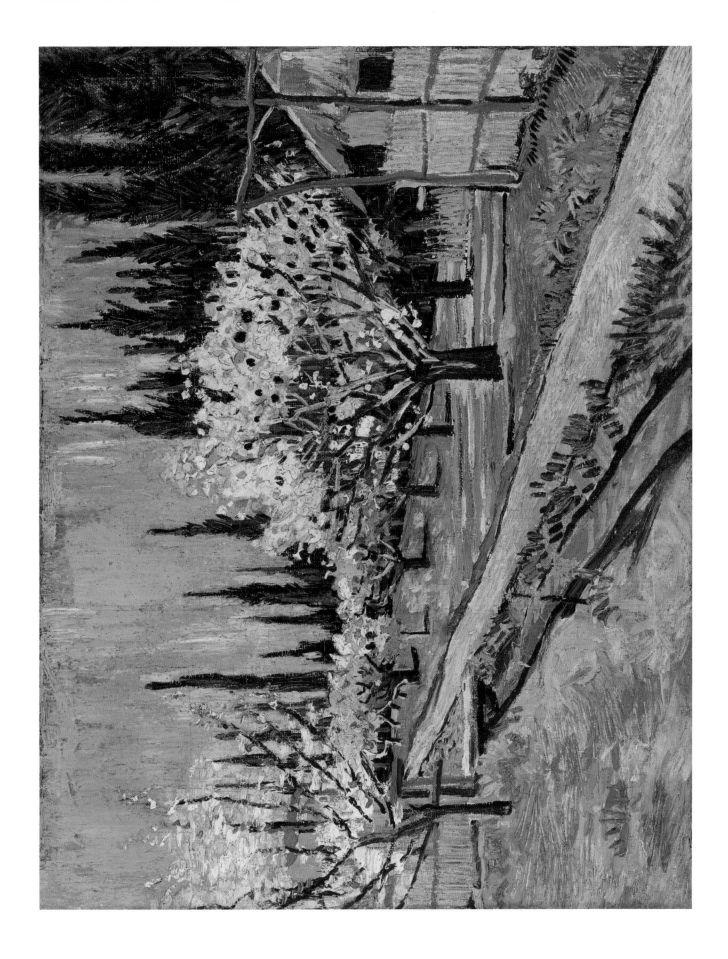

Other Titles in the **"Masters of Art Series"**:

Renoir

Rembrandt

Raphael

Rubens

Paul Gauguin

Diego Velázquez

Pieter Bruegel the Elder

Wallartmadeeasy.com